Poetry by Amy Charlotte Kean
Illustration by Jack Wallington

First published 2020 by Fly on the Wall Press
Second print run August 2021

Published in the UK by
Fly on the Wall Press
56 High Lea Rd
New Mills
Derbyshire
SK22 3DP

www.flyonthewallpoetry.co.uk

ISBN: 978-1-913211-15-8

Contents

"One is tempted to say that the most human plants, after all, are the weeds." (John Burroughs, 1881)

Between 1879 and 1941, two unlisted buildings in Peckham served as refuge to forty-seven individuals. It was a site of urban legend; asylum for the disgraced rebels and mentally unorthodox of the time. Those who did not fit an aesthetic template; who refused to respect society's imposed sexual restrictions. The atypical men who had failed and been failed by the system and outspoken women who only a few centuries prior would have been burned as witches. Little is known about what went on in those houses, as its lodgers were heard but rarely seen. Neighbours spoke of wild all-night parties, raucous laughter, mirrors thrown from the bedroom windows with such force they dented the pavement below and sounds of babies crying bloody murder within the damp foundations.

On a trip to the UK, the 20th Century French philosopher Lucien Perrot became fascinated with the concept of this home for outsiders, intrigued by the rumours of rabid non-conformity. Perrot paid a visit, banging on both front doors with a pack of photographers and journalists ready to catch a glimpse of what - and who - was inside. When the doors stayed closed, he was enraged, publicly dismissing the illegal tenants as "les mauviettes"- the weaklings, or weeds - none brave enough to meet him. He wrote a series of scathing essays about those foolish enough to believe their self, their identity, was bigger and better than society and predicted for them an isolated and depressing end. But those who knew described the Safehouses as happy: scenes of liberation, love affairs, art and kindness. Where all were allowed to be themselves, and grow.

Both houses were bombed on 6th June 1941 during the Blitz. No breathing bodies were found. All that survived the blaze were random objects: toys, lipsticks, stage costumes, a microscope and the collection of perfectly preserved poems you see here: author(s) unknown. Since the bombings, the houses remain untouched, but all manner of wildflowers have grown under the floorboards in every room. These weeds exist in harmony, and have become a landmark of local beauty. The cornucopia of unique notes provides an unfettered reminder of the rebels; that there was once unbridled life within those walls.

Ricinus communis
(Castor Oil Plant)

Common is a common
enemy, tool of the power-
ful, honed persuasion robust
as buses *so weak hate weak lost
bury lost*. Charity craves the
sick / The world needs the
weeds to define what it means
to rise, to thrive an underdog.
Remedy, when all that's
left is pale irrelevance / My
story is timeless, I'm told.
Fresh as a bloody sword
twisted and withdrawn by ag-
ile wrists of expert assassins.
Protector of the poorest,
enemy of castes. All
that is and ever will be
deep, relentless red.

Anagallis arvensis (Scarlet Pimpernel)

Gluttons for punishment love the Gemini.

The allure of double living, violent contradictions

that bury the soul; the positive reinforcement of a rubber mask;

hidden spots of salamander you can feel before you see.

Soothing and translucent as soft melon in midsummer.

Geminis pounce.

When succumbed, it's easy to be tricked into thinking

Gods and monsters are the same thing.

Rosa canina (Dog Rose)

I was so simple.
An overcrowded immunity
to a purity you sought
to overcompensate
for, calming me down
as if anaesthetised.

Would you mimic my thorns?
Play them like a harpsichord
by fevered gaslight.
Soak my legs?
Trip them like a faulty hip
at the bottom of autumn's stair.

You say I drove you to spirits
You sent me, dogged
and careless into the
seasonal transition, but
You created it, didn't you?
You named it, didn't you?
Saints die, but not devils, they
mutate and splash with memetic charm.

Remember
Remember when I said
you were living proof
karma doesn't exist?
But it does, doesn't it?
We knew it even then.
And you know it, now.

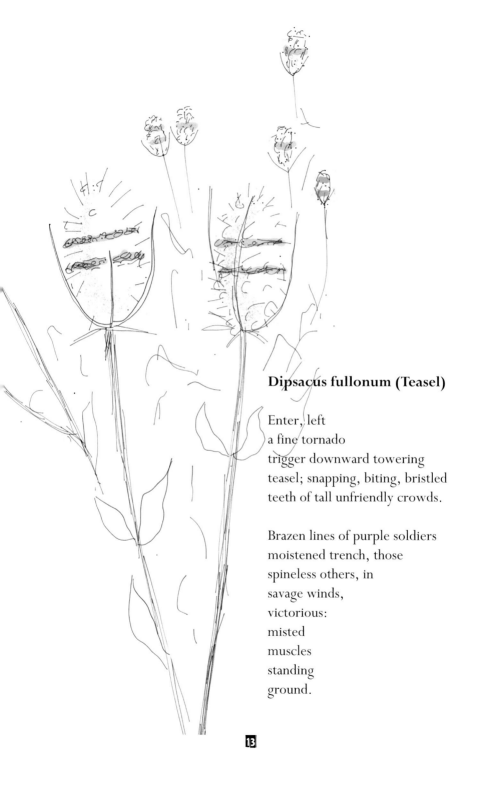

Dipsacus fullonum (Teasel)

Enter, left
a fine tornado
trigger downward towering
teasel; snapping, biting, bristled
teeth of tall unfriendly crowds.

Brazen lines of purple soldiers
moistened trench, those
spineless others, in
savage winds,
victorious:
misted
muscles
standing
ground.

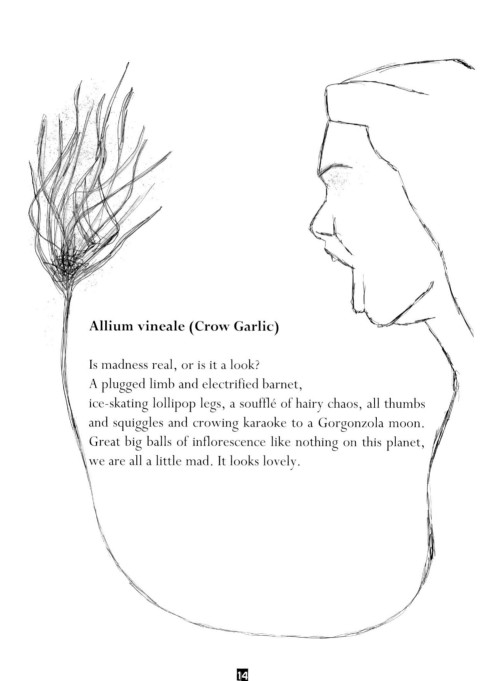

Allium vineale (Crow Garlic)

Is madness real, or is it a look?
A plugged limb and electrified barnet,
ice-skating lollipop legs, a soufflé of hairy chaos, all thumbs
and squiggles and crowing karaoke to a Gorgonzola moon.
Great big balls of inflorescence like nothing on this planet,
we are all a little mad. It looks lovely.

Soleirolia soleirolii (Mind Your Own Business)

Damn this brain! This energy. This reluctant calling.
It's not shyness, *per se*. Heaven knows what shapes us.
Damn this rudeness, this hardwired nature. Damn Mother Nature!
Damn her delicate green fingers, if fingers are what cast her spells.
Damn the endless friction between her and God. Damn them both
for crafting this problematic engine, damn my emerald carpets
those awkward moments, my lazy salutes, uncontrollable in other lands
when I felt too damn foreign to cope. Forget them. Damn my fuss.
Damn their unwavering spunk. The shouting, the barks that roughen my soul.
Damn waiting for wilt. Damn letting the loudest lead. They sent us here.
It's a risky game, war. A day later, we would all have been dead.

Jacobaea vulgaris (Ragwort)

Plush and raggy in the meadow's centre,
Boxed like a gladiator, all hackles and chains.

Ain't looking for trouble, promise. Ain't
no deadhead proletariat pocket-watcher.

Catch me wheeling, dealing jet-black bed bugs
Loved-up lonely caterpillars at visiting time.

Savvy pig-dodger for twisted pollinators
Scatter me here. I won't trick you, promise.

Caged and boxed. It's like Alcatraz, I swear.
Think of me as a landmark infamy,

feature piece in your rancid palace.
Scatter me, plush and raggy in the meadow's centre.

I won't kill you, promise.
A poison makes the ending sweeter.

Pilosella aurantiaca (Fox and Cubs)

My advice to my unborn is this:
growth won't be easy.
Nor bloom: the kind of shine one accumulates, that
spreads like camera flash.
A warmth, memorable as 'old fashioneds' licking
the curl of your tongue.
A kindness that settles and coaxes the dust open so
new seeds may fall in, making it richer for the next.
What I tell to my unborn is this:
growth occurs when you rise, hands held.
When you allow yourself to bless the intricacies of
your neighbour.
We are all children.
So when you eye the open buds of fellow cubs
whether small, or torn; are proud of every shade,
the strength of each to smash through hard earth,
when you thank the sun for all of us, when you can
say you are part of a pack more powerful than its
parts.
And you know that to be true.
You are grown.
And it will last forever.

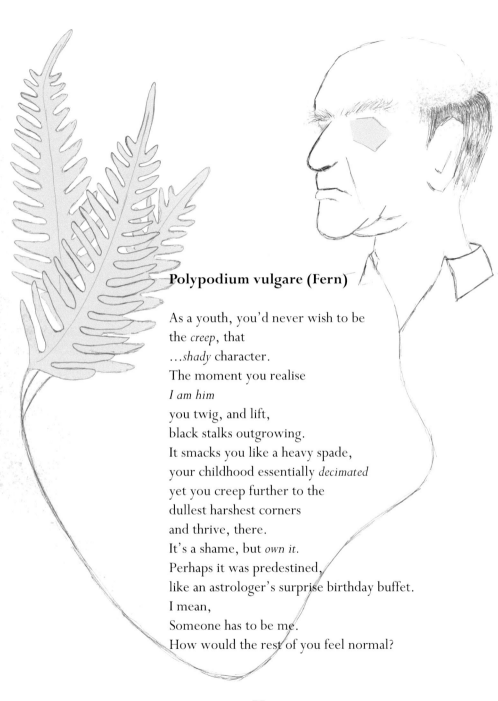

Polypodium vulgare (Fern)

As a youth, you'd never wish to be
the *creep*, that
…*shady* character.
The moment you realise
I am him
you twig, and lift,
black stalks outgrowing.
It smacks you like a heavy spade,
your childhood essentially *decimated*
yet you creep further to the
dullest harshest corners
and thrive, there.
It's a shame, but *own it*.
Perhaps it was predestined,
like an astrologer's surprise birthday buffet.
I mean,
Someone has to be me.
How would the rest of you feel normal?

Pseudofumaria lutea (Yellow Corydalis)

Oh, canary princess: never be less!
Loud as trumpets, soul, bold as brass
an infallible flame endemic of endless class.

Where the earth breaks, you bloom defiant,
sweet among the cracks, brave yellow pinching dark brick.
Flushed, transforming bin to ballroom

your surroundings pop. Whether forlorn tower
or abandoned corner. Even sashaying across the moon
you glimmer, any place. Oh, this is your time.

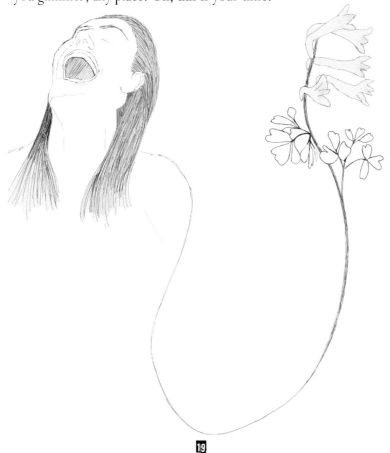

Leucanthemum vulgare (Ox-eye Daisy)

These young girls daydream of
bleached churches, gooey futures,
agony of an unknown, undressing.
They pluck my fingers with
a brisk uncertainty knowing
love, unrequited, is the safest of all.

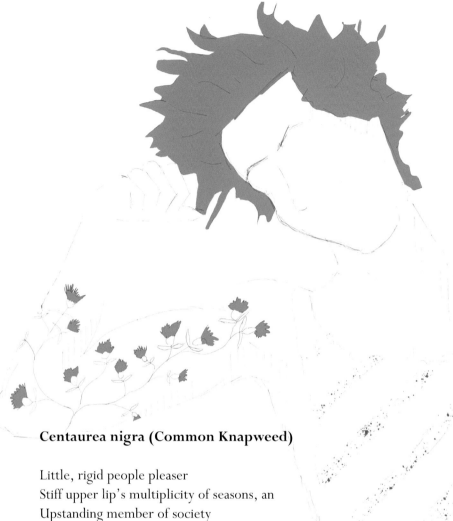

Centaurea nigra (Common Knapweed)

Little, rigid people pleaser
Stiff upper lip's multiplicity of seasons, an
Upstanding member of society
Subservient as an undular bore.

Yet under my tufts, a covert anarchy
Hardhead punk rockers, neon nod moshers
Sid Vicious thistles with Deep Purple whistles
I'll smash pineapples
With my noggin all over the common,
God. Save our gracious weeds.

Buddleja davidii (Butterfly Bush)

I don't look for danger, but I need to know it's close.
Like on a rooftop, drunk and heavy, tipped by cheeky winds.

I wish to be a standalone specimen in waste grounds.
Dancing in the dark like a purple butterfly, like no one's watching. *No one's watching.*

I'll find an abandoned building to wrestle myself in.
Make my shadow big and intimidating with long snout and horns.

It'll look broad and sinister but we'll both know our secret.
High, we'll paint the walls with fevered streaks of royal red.

At my most magnificent I am tutti-frutti ornamental.
Can re-nature a space without even trying.

I need to know that at any moment, anything could happen.
It is the only way, I think, I can stay alive.

Life is simpler when you don't think too much.
I don't want to die, I just need to know it's possible.

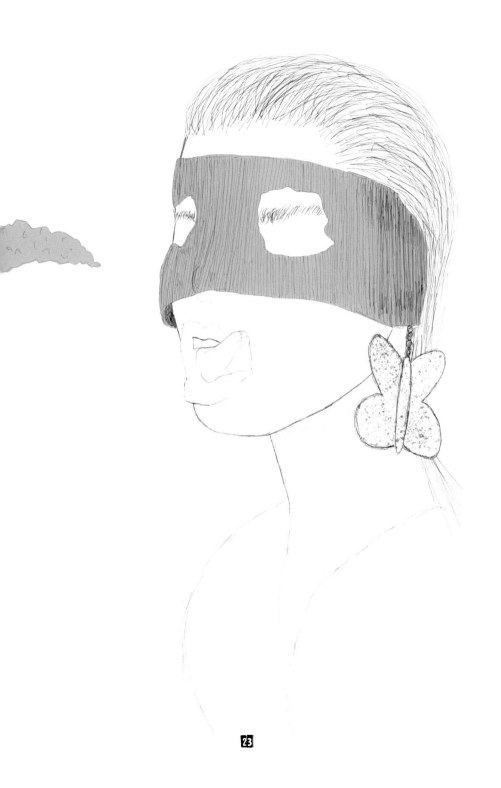

Geranium robertianum (Herb Robert)

Child on Baker Street with burnt hair
and periwinkle slacks called me too much.
Man on the radio spitting suffocating chords of
Great Depression called me too much.
My girl called me too much.

Smoked my subtle scent too much.
Herd of teddy bears, too much.
Hazy games of hide and seek, too much.
Resilient, pastel boomerang, too much.

I'll give them too much.
I'll show them too much.
To the norms, the pudding-reared, white bread smirkers, God-fearing Sunday
shoe-wearing cult-de-sacs with their convex memories and goldfish craniums,
to the righteous; Oxygen is too much.

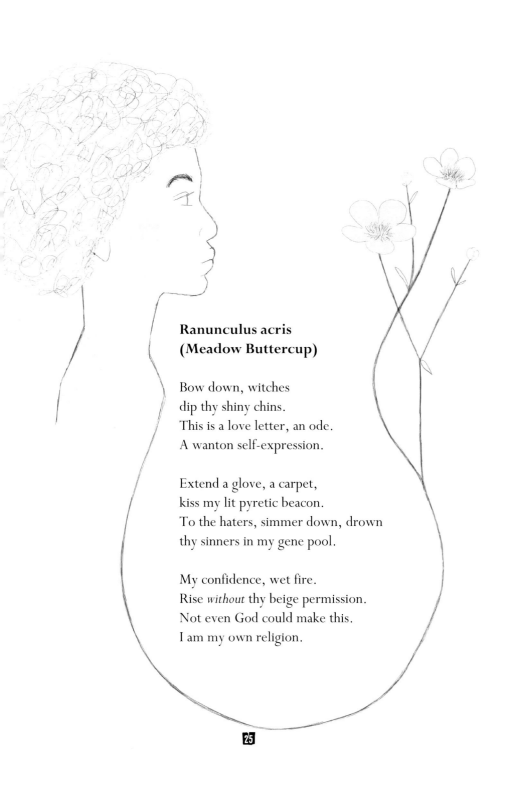

Ranunculus acris
(Meadow Buttercup)

Bow down, witches
dip thy shiny chins.
This is a love letter, an ode.
A wanton self-expression.

Extend a glove, a carpet,
kiss my lit pyretic beacon.
To the haters, simmer down, drown
thy sinners in my gene pool.

My confidence, wet fire.
Rise *without* thy beige permission.
Not even God could make this.
I am my own religion.

Fumaria officinalis (Common Fumitory)

When the night stretches like a hairnet across unruly afternoons, you want to sleep, it's all you think of. Eyes rubbed wide for a drift that won't

settle. You try bamboozling your brain so it slips down the back of your head and into thick fog, to gasping clouds. Rainbows smacking like sleet on the translucent smoky glass of a pink

submarine. Imagine diving into perfectly carved candyfloss, scrambling through nebulous gates to freedom. The grind of irregular teeth that taste the sweetness of oblivion. The brief respite of a

dream. You want to sleep, but it never comes.

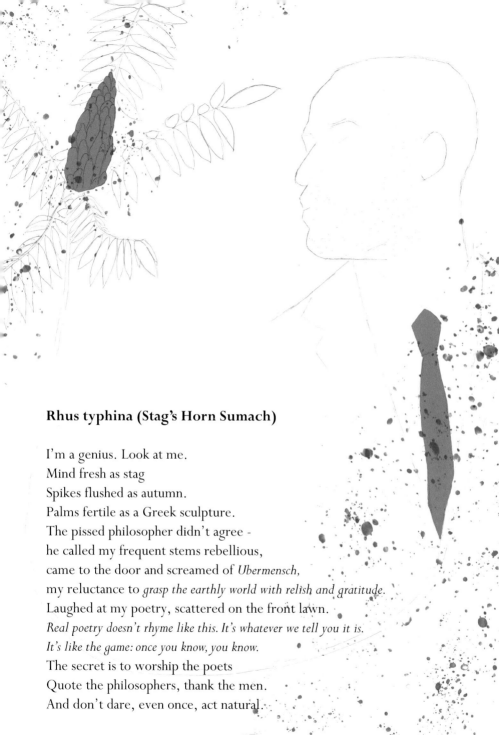

Rhus typhina (Stag's Horn Sumach)

I'm a genius. Look at me.
Mind fresh as stag
Spikes flushed as autumn.
Palms fertile as a Greek sculpture.
The pissed philosopher didn't agree -
he called my frequent stems rebellious,
came to the door and screamed of *Ubermensch,*
my reluctance to *grasp the earthly world with relish and gratitude.*
Laughed at my poetry, scattered on the front lawn.
Real poetry doesn't rhyme like this. It's whatever we tell you it is.
It's like the game: once you know, you know.
The secret is to worship the poets
Quote the philosophers, thank the men.
And don't dare, even once, act natural.

Hypochaeris radicata (Cat's Ear)

You've got to kick down a door.
Prize the wood from its hinges.
So uninvited, in my yellow dress.

Maleficent beams stalk my frame across the marble floor.
My name must've slipped from the guest list.
An oversight, no drama, I'm here now.

Rotten souls name what they can't understand,
some biblical legacy, assumptions of wickedness
like the dandelion, before me.

Clones succeed. Note that, kindly.
The thick treacle of familiarity; a hungry
saccharine mess.
As rigid and safe as a scold's bridle.

I hear them say, *what have we done,*
What have we done to bring her here?
And I know that whatever I am, it's working.

Trifolium pratense
(Red Clover)

Funny how we
warm to the bee
when it says sorry
by dying
immediately.
Such in its last
woeful buzz
I made a montage
of best bits, my
cherry sponge my
Danish wonder a
sign of peace; of
glowing testimony.
It was worth it,
says the spiteful
little shit.

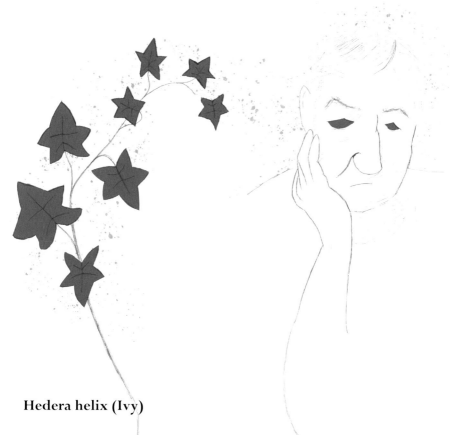

Hedera helix (Ivy)

If we work backwards from the old man, his story has a happy ending. A ravaged narcissist - whose white marbled leaf veins throb through tight grey garments - becomes a guiltless work of art: philanderer, creator of chaos who shapeshifts into ruthless social climber, taking back his soul from the devil. If we work backwards, this viral romping beast evolves into boy, with dreams of limitless love. Instead he's named a nuisance, terror, this boy who dies a baby, filling the room with hopeful cries, oblivious to his woeful fate.

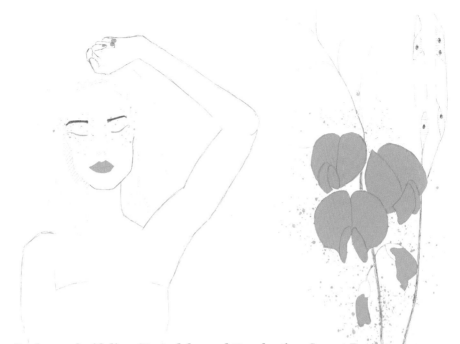

Lathyrus latifolius (Broad-leaved Everlasting Sweet Pea)

Since birth there've existed immeasurable expectations:

- Blend into backgrounds.
- Prosper via submission.
- Find love.
- Perish, as and when required.

Yet wildflower to the core, these expectations do not satisfy my urge to combat, arm my cannons. Tilt; prepare for mutiny and outlandish fire. Seed pods cracking open as they twist,

shoot, and leave.

Heracleum mantegazzianum (Giant Hogweed)

Humans dig fear.
It's evolutionary.

> The squeezing adrenaline
> of rumbling threat,
Rising bile of toxic terror
> staccato pricks on the back
> of your neck.
> His nameless, blistering
> unnatural wretch:
> Of mother nature's twisted sex.

> An ugly jump that hides their arms, shields
their eyes

> Freshly
> cut fear. A
> gruelling
> reminder
> of being
> alive.

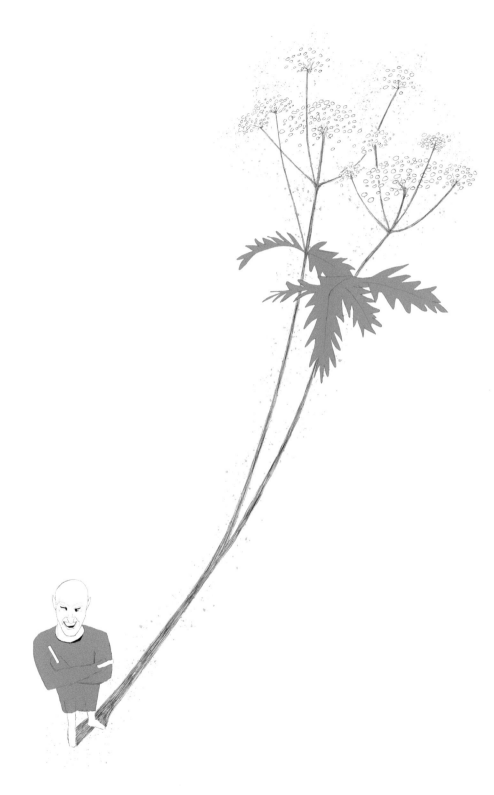

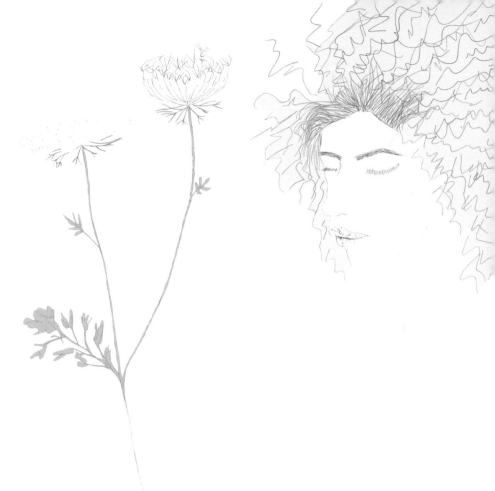

Daucus carota (Wild carrot)

She's like a cake * spread-eagled under commemorative candles * filthy, gorged on * peeping at windows * thick noble frosting * a look, lick * tiny creamed slices * those flushed, clotted drops on laced white fingers * the confectioner's tips * sunk teeth into twilight * a thousand crowns * those bonbon curves * they sing to me * oh honey * don't give yourself diabetes

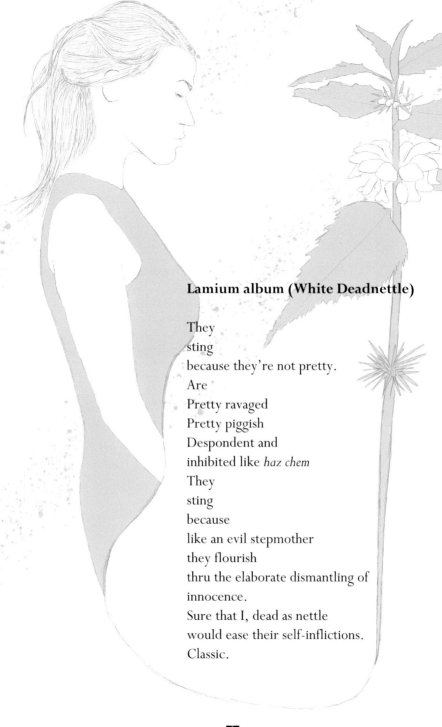

Lamium album (White Deadnettle)

They
sting
because they're not pretty.
Are
Pretty ravaged
Pretty piggish
Despondent and
inhibited like *haz chem*
They
sting
because
like an evil stepmother
they flourish
thru the elaborate dismantling of
innocence.
Sure that I, dead as nettle
would ease their self-inflictions.
Classic.

Hirschfeldia incana (Hoary Mustard)

Kissing is our revelation.
That thing we're made for,
divine purpose and raison d'être.

Attaching your soul to theirs in a magnetic clasp,
pulled invisibly in that last irrepressible millisecond.
Pecks in their lorry load, bred to mingle, and stretch.

A gravelled cheek, a china hand, a proud and lifted forehead
The surging nerves of eager lips.
An angel's quilt wrapping you in deep comfort.

Kissing homes the bastard, and melts the winter frosts
Kicks your heart like Spanish mustard, every grain
blowing the head off what we believed might ever be.

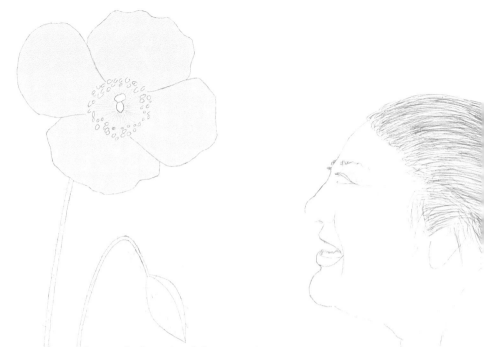

Meconopsis cambrica (Welsh poppy)

Happiness is alleged victory; a mountain's peak that screams my name across an unwilted horizon; words skimming over trampoline lands that root for me, for my endeavours. Age is so often blind emergence; Mexican waves of tangerine jewels sprung from bare soil to pummel your make-believe boundaries until you see, just as you, I belong here.

Linaria purpurea (Purple Toadflax)

Perfect, deconstructed
What can I teach you about perfection?
Groan through this zipped-up corset of everlasting silver,
stems for days, the toast of summer.
I wash my grace in a mirror,
face cased like an ornament,
sweep,
bedazzle atop a spiral staircase
to greet my people.
They see the gloss, an amethyst filter
and little else. My
success, my fatal flaw.
I am weed
I am perfect
For God's sakes, be careful.

Iris foetidissima (Stinking Iris)

We got beef. Like lipstick terrorism and
red letterboxes. Rich beef, tough beef.
Beef on a Sunday and Suicide Tuesday.
Rubbed down dank in covert doorways.
Beef with the bourgeois, beef getting sticky.
Childless warriors, chasing thoroughbreds.
Beef with the bellboys, beef in the basement.
Peace talks and scenic liberty kicking up a stink.
A stink is, as always, mightier than the sword.
Sleep standing up with one eye open beef.
Pray, wait for the rain. We are rare. Well done.

Oenothera biennis (Evening Primrose)

I remember the first time I died. It was a Saturday,
as Saturday is the most common day to die, in many
ways. Perhaps at the stroke of midnight - what a cliché! -
I lost feeling. Overdosed on daylight and withered, real dead.
Deceased as the Baiji White Dolphin (or dignity).

By the morning, I was resurrected.
Like an obvious Jesus, or worm cut in half.
And then every dusk, as the crafty nightlights beckoned
and our city's hot borders whumped, it was prewritten.
At the height of my euphoria, I dropped down dead.

In the morning, as I was born again again
you popped the kettle on, and told me to calm down.
My dear, I said, holding a glass bowl up to your eyes.
I am perfectly calm. And this is what makes you nervous.
What is the best rebellion, for a woman? They ask.
Well, of course, it is to live! I say, aloud. *It is to really live… each day.*

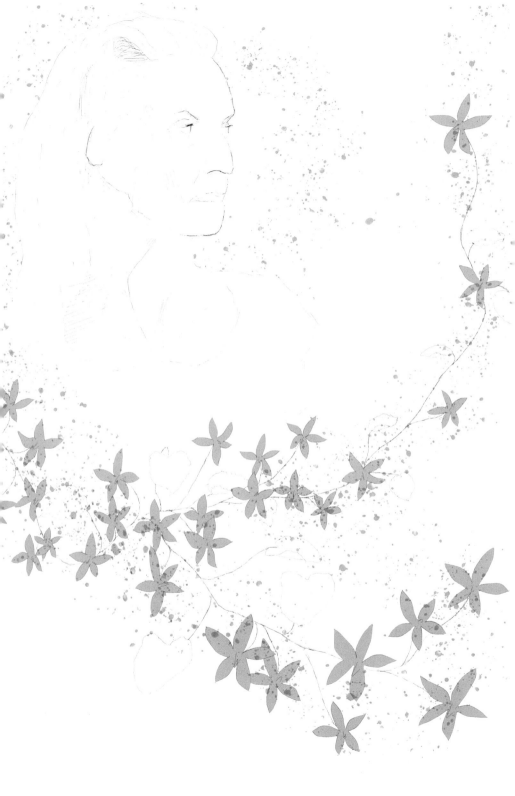

Campanula poscharskyana (Bellflower)

A flickered memory of porcelain short-night summers, dotty and hypnotic. Pouring roots into gaps slim as fairies' wrists. My bravado punched the air with polite havoc, swept the children's faces as they ran to catch the light. I am. Spilled, like a firework, sherbet explosion. Once, forgetting my contagious shimmer I wondered why I was born at all: hard as statue, yet easily torn from earth. I am. Fragile to all who knew. In autumn, the children grew and moved away. I gave them distant waves, a delicate toast to persistence. My history; such enchanting periods of contrary lavender. They waved back, as blue became brown. I hope I showed them right. That a rebellious life is one well-lived.

Author Biography

Amy Charlotte Kean is a weed, known for her persistence and unpredictability, much like the buttercup, or dandelion. She's an award-winning advertising strategist, innovator and creative from Essex who's worked with some of the world's most wonderful brands like Nando's, Sony and Jean Paul Gaultier to do unexpected cool shit that benefits society.

Her number 1 bestselling debut book, The Little Girl Who Gave Zero Fucks is a feminist fairy tale and ode to everyday bravery, hated by The Spectator and Trump supporters and loved by women and men who see the power in worrying less. Her poems, rants, reviews, flash fiction and opinion are littered across websites like The Guardian, Huffington Post, Glamour Magazine, Disclaimer, Ink, Sweat & Tears, Abridged and Burning House Press alongside her regular column on creativity for Shots magazine.

She's a university lecturer, founder of DICE, an inclusion initiative in the events space and ambassador for Writing Through, a charity that builds confidence through conceptual thought.

Illustrator Biography

Jack Wallington is a landscape garden designer specialising in nature led, beautiful spaces with a contemporary, light touch to hard landscaping, furniture and features. He views gardens and public green spaces as a mini-ecosystem and living, dynamic works of art that must also be practical, to be enjoyed and create lasting memories for people, too.

Throughout his life Jack has studied different forms of art, and has a current interest in line drawing for its ability to quickly capture energy and form. In all of his work, from pictures to gardens, colour is absolutely critical, used to set the tone and mood.

As a writer, his debut gardening book, Wild about Weeds: Garden Design with Rebel Plants was named The Times Gardening Book of the Year, exploring the virtues of plants we've long ripped out and cast aside. In *House of Weeds,* his quick ink sketches created on iPad are weaved around Amy's
poems that challenge our view of the world.

About Fly on the Wall Press

A publisher with a conscience.
Publishing high quality anthologies on pressing issues,
chapbooks and poetry products, from exceptional poets
around the globe.Founded in 2018 by founding editor, Isabelle
Kenyon.

Other publications:
Please Hear What I'm Not Saying
(February 2018. Anthology, profits to Mind.)
Persona Non Grata
(October 2018. Anthology, profits to Shelter and Crisis Aid
UK.)
Bad Mommy / Stay Mommy by Elisabeth Horan
(May 2019. Chapbook.)
The Woman With An Owl Tattoo by Anne Walsh Donnelly
(May 2019. Chapbook.)
the sea refuses no river by Bethany Rivers
(June 2019. Chapbook.)
White Light White Peak by Simon Corble
(July 2019. Artist's Book.)
Second Life by Karl Tearney
(July 2019. Full collection)
The Dogs of Humanity by Colin Dardis
(August 2019. Chapbook.)
Small Press Publishing:The Dos and Don'ts by Isabelle Kenyon
(January 2020. Non-Fiction.)
Alcoholic Betty by Elisabeth Horan
(February 2020. Chapbook.)
Awakening by Sam Love
(March 2020. Chapbook.)
Grenade Genie by Tom McColl
(April 2020. Full Collection.)

Social Media:
@fly_press (Twitter)
@flyonthewall_poetry (Instagram)
@flyonthewallpoetry (Facebook)
www.flyonthewallpoetry.co.uk

More from Fly on the Wall Press...

Alcoholic Betty by Elisabeth Horan

ISBN10 1913211037
ISBN13 9781913211035

The brave and vulnerable poetry collection of Elisabeth Horan's past relationship with alcohol. Unflinchingly honest, Horan holds a light for those who feel they will not reach the other side of addiction.

"This is the hole. I go there
On Sundays. I go there after dinners
Before school --- mid work day
After lunch with the boss Mondays

The hole has Hangover coal
To paint my face to smudge
In the acne, rosacea, colloscum"

"Alcoholic Betty, we know the story. She died. Or did she? Through the "hours of penance" that is alcoholism and its attendant chaos-math and aftermaths, recurrent false dawns and falsetto damnations, Elisabeth Horan forges a descent/ascension pendulum of fire poems that are not "a map to martyrdom" - but a call to "go nuclear - Repose. Repose." Alcoholic Betty, we know the story. She died. She died so she could live."

- Miggy Angel, Poet, Author and Performer